BEGINNER'S BOOK OF ANATOMY

ADRIAN HILL

DOVER PUBLICATIONS, INC.
Mineola, New York

Bibliographical Note

This Dover edition, first published in 2007, is an unabridged republication of the work originally published in 1962 by Reinhold Publishing Corporation, New York, under the title *The Beginners' Book of Basic Anatomy*. The four color plates in the original edition have been reproduced in black and white for the Dover edition.

Library of Congress Cataloging-in-Publication Data

Hill, Adrian Keith Graham, 1895–
 [Beginners' book of basic anatomy]
 Beginner's book of anatomy / Adrian Hill.
 p. cm.
 Originally published : The beginners' book of basic anatomy. New York : Reinhold Pub., 1962.
 ISBN-13: 978-0-486-46004-8
 ISBN-10: 0-486-46004-5
 1. Anatomy, Artistic. I. Title.

NC760.H49 2007
743.4'9—dc22

 2007016079

Manufactured in the United States of America
Dover Publications, Inc., 31 East 2nd Street, Mineola, N.Y. 11501

Contents

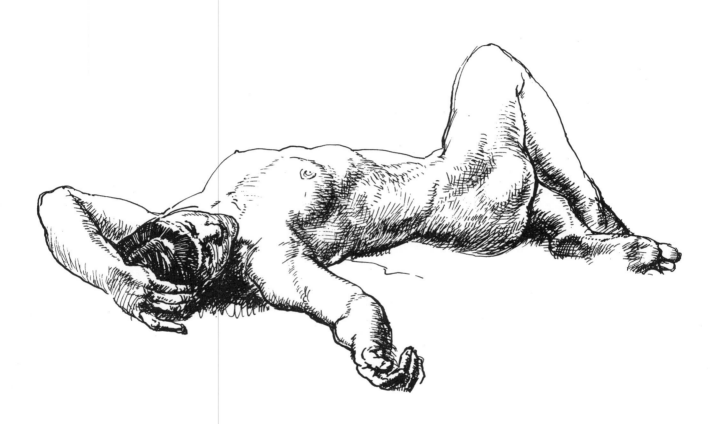

Principles and Practice

In the gradual but significant departure from the realistic or academic representation of the human form, the principles of basic anatomy are in danger of being neglected and their importance disregarded, if not, in some cases, completely ignored. Figure subjects, especially those depicting the nude, which in the past played so important a part in the painter's subject matter and which occupied an honoured place both in our galleries and in the esteem of the picture-loving public, have been in recent years relegated to a position of doubtful aesthetic value. The ideals of both the male and female forms, cherished and portrayed by the old masters, have been superseded by the portrayal of other organic forms which, while having a life of their own, bear little or no resemblance to, let us say, the Adam and Eve which past generations were brought up to believe ' God created in his own image.' Moreover, human physical beauty as something to be revered and copied with loving accuracy has become something of an anachronism and when exhibited objectively is generally viewed with vague suspicion. Of what use, then, is a knowledge of anatomy, implying, as it must, a special course of study in the workings of the human body, its skeletal construction and muscular coverings ?

Indeed, it has often been argued that the actual value of such specialised knowledge may well have been overrated. In actual proficiency of acquirement it has often proved a veritable stumbling block to the sensitive draughtsman, while to some artists and painters it has proved absolutely harmful to their work.

On enquiry, however, it can be shown that it was the rigidity of the instruction (which had been paraded rather than taught) which caused anatomy to have been so misemployed. Text book rules became a substitute for knowledge. The ruthless medical slant on the body's construction, when bones and muscles, torn from their pictorial context, were held up for isolated inspection,

7

had little or no connection with the living, breathing human being which the student was required to represent, dehumanised or devitalised the very aim for which it was intended.

Like perspective, anatomy, to be acceptable to the student, should be presented as an aid and not a hindrance to his artistic aims and ambitions, in no form of stern directive but as a key to turn a stubborn lock and reveal the working parts, without which any figure, nude or draped, young or old, will remain wooden or lifeless —in short, a ' lay figure ' and not a real one !

It is, after all, what makes the real body ' tick ' which should first rouse our curiosity and then stimulate our desire to make use of this newly acquired knowledge. And in my experience, a page of demonstrations is worth a volume of text.

With this in mind and believing, as I do, that the eye more easily follows a diagram than digests a page of print, the letterpress in the following chapters will be restricted mainly to essentials in order to give the pictorial examples ample room to ' pin point ' my meaning.

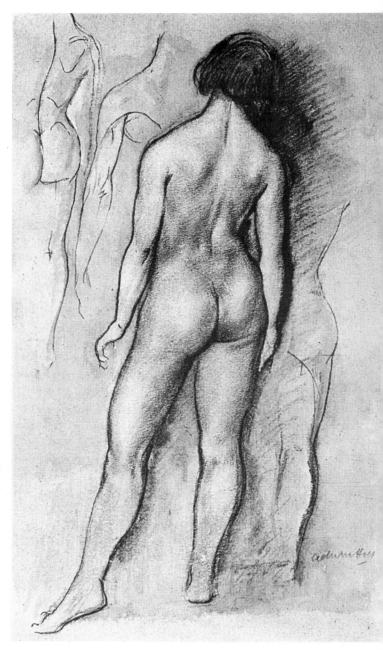

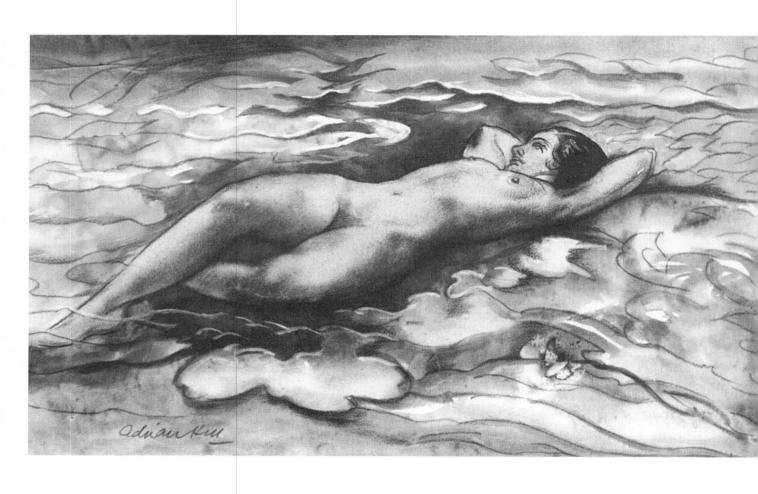

Basic Anatomy

If the term 'artistic anatomy' inevitably conjures up the skeleton, it should be viewed without any feelings of distaste, but rather with a sense of wonder at such a miracle of construction. Apart from the amazing way it works, it provides a unique design for the draughtsman. The delicacy, plus strength, of the bony construction, and the multiplicity of the shapes involved, makes accuracy of proportion essential and tests the eye and hand to a marked degree (illus. pp. 20–22). But in order to appreciate more properly the flexible precision and rhythmic mechanism by which the body works and moves, let us first see how far we can build up the figure without any recourse to a knowledge of what lies beneath. In order to learn if this hidden knowledge is of any use to us, I hope to demonstrate by the accompanying diagrams that we can indeed go some way to construct a substitute figure for the real thing, and more important still, that in concentrating first of all on the outside shape, as we must, we

will have learnt a very important lesson, for if one thing becomes essential to a good life drawing it is that we make our figure both solid-looking and round! Two absolute 'musts' as we shall see.

The devices I have used for my illustrations are in no way new, but I hope it will be seen that I have developed them in a logical way. My tubular man, within the strict limitations of robot movement imposed on it by an entire lack of knowledge of bones or muscles, can approximate to many static positions and some actions taken by a human being.

Moreover, my tubular man does resemble the human form in that the various cylinders by which he is made are of different widths and lengths, just as in nature. The widest and longest cylinder or column (a better word in this connection) is the body or trunk; the next in thickness are the thighs, then the lower legs, and lastly the upper and lower arms, which are roughly the same proportions as are the upper and

lower legs. The neck is by far the shortest cylinder of all. The head is represented by a solid egg shape, and hinged ' wedges ' will suffice for feet, with a similar formula for hands (illustrations on pages 16–18).

Nine cylinders. How far can their movements correspond to those of the human figure ? In order to depict the best position we must now consider the tube which represents the trunk to be made of some *flexible* material, otherwise, the body part, remaining rigid, can only bend in its own length, at right angles to the legs (see illus. on page 17). And here we know that we can move that portion of our own body in four distinct directions—forwards, to the extent of being actually bent double ; backwards, but here the movement is limited, as it is when we *bend* sideways, and—in a still more restricted fashion—when we *turn* or *twist* our body to the side while keeping the legs rigid.

It is these movements of the trunk which now will necessitate the addition of two indispensable parts, *inside parts*. One I shall describe and draw as a basin situated on the top of the thighs and into which the flexible column of the body is *inserted* (illus. on page 19). This basin acts as a base and supports our trunk and is clearly indispensable when we depict our tubular man in a sitting or reclining position. It also keeps it in position when we touch our toes ! So far so good. But another question now arises. Why can the trunk thus freely bend forwards, but for normal people (I exclude any acrobatic movement as abnormal throughout this chapter) only to a limited extent backwards. And this is where the back bone can make its bow (the word is apposite as we certainly could not regain the upright position after making such a bow without the aid of a backbone!). Running down the back portion of our trunk, then, this bone is made up of numerous small parts, articulating one on top of each other (with a pad between each, as shock absorber) so that at one point in our ' backwards bend ' the movement is inevitably halted. It is as simple as that (see illustration on page 22).

In order to explain the restricted movement of the trunk sideways, we must now introduce a series of bones (our ribs) con-

structed to form a hollow *cage* or *basket* which is fitted in to the body and fixed to the backbone behind and in front to another short bone (the breast bone) (see illus. on page 21). It is obvious now that when we bend over sideways the lower margins of this cage meet the upper rim of the basin (or pelvis) and stop further movement. (See illustration on page 20).

It is now possible to understand why the trunk is free to bend *right over* in a frontal direction but is restricted in its other sideways and backwards movements. It is because it has no bony obstruction to impede its way.

We can now turn to the legs and arms, for inside these cylinders we have to insert bones. In the upper leg, or thigh, one strong bone goes down *the middle*. The rounded head of this bone fits into a deep socket, *hollowed out* in the base of our pelvic basin. In the lower leg, *two* bones are situated side by side. One, the shin bone, the stronger of the two, runs down *very close* to the *front* of the cylinder. The other runs down at the *side* of the shin bone, to which it is fixed at the *top* and *bottom*, but does not

betray its presence, except at the base, which we call our outer ankle. Our inside ankle is formed by the shin bone. A pulley cone or flat disc (knee cap) unites the two.

Before we proceed further, it is interesting to compare the various movements of the legs with those of the arms, which will be seen to be even more complex and versatile, and the explanation for which will then be more readily understood. (See illustration on page 25.)

While there is only one bone in the upper arm, there are two in the lower (as in the lower leg), but these in the lower arm (or forearm) have a special movement in themselves which I will explain a little later. While the head of the bone in the upper arm (like that of the bone in the thigh) rotates in a socket, this hollow is very shallow and thus allows a great freedom of movement and is carved out of a flat, triangular-shaped bone which I can now mention and which we call our *shoulder blade*. It is fixed on its outside edge to the corresponding edge of the last bone to be named—the collar bone (as we call it)—and both these bones, especially the latter, lie very close to the

surface of the trunk (that is why the collar bones are so vulnerable to fracture in such games as Rugby football and, incidentally, why our poor shin bones get so easily bruised in cricket and hockey).

What is so peculiar about the bones in the lower arm is that one (the radius) actually rotates over the other (the ulna). And you can see at a glance how necessary this unique articulation is, if we are to carry out all the turning movements of the hand and wrist. There is hardly a movement or action or gesture which we make during the day with our arm and hand which does not call into action this adjustment in which the radial bone turns over on its neighbour, the ulna, and thus motivates the arm (see illustrations on pages 60 & 62.)

But the bones, indispensable as they have been shown to be in making our robot figure more closely resemble the human figure, are only part of the machine which motivates our bodies and enables us to move our limbs in so many different ways.

By their addition our tubular man is far less stiff and is beginning to show signs of something pertaining to *grace*—and a desire to move imperceptibly and noiselessly from one position to another instead of being content or restricted to merely striking attitudes !

In order to move thus we must *clothe* our tubular man with muscles and thus effect the final metamorphosis from robot to living man.

Dramatic lighting here emphasises the muscular system in strong action.

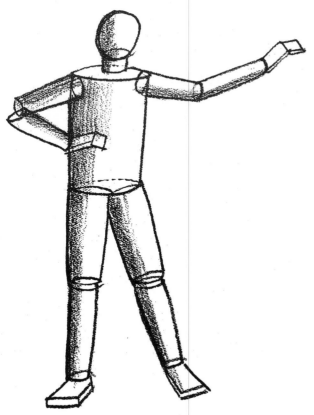

Front View

Various robot movements which may be said to correspond to those of the human body.

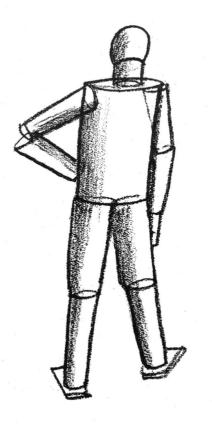

Back View

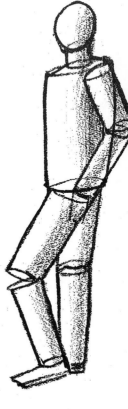

Side View

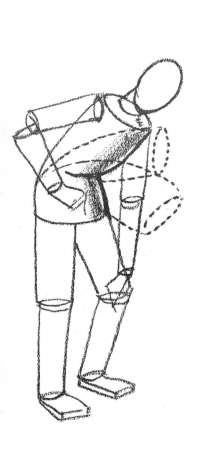

Trunk can bend forwards (double).

Trunk can bend sideways only to a limited extent.

Trunk can bend backwards only to a limited extent.

17

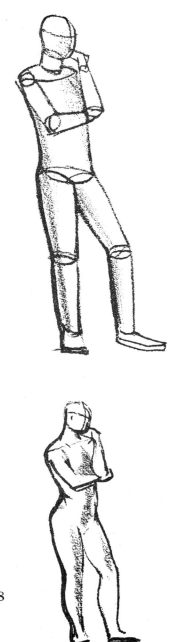
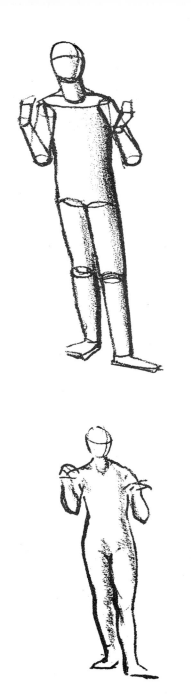
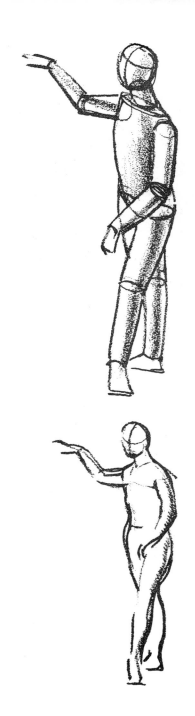

18

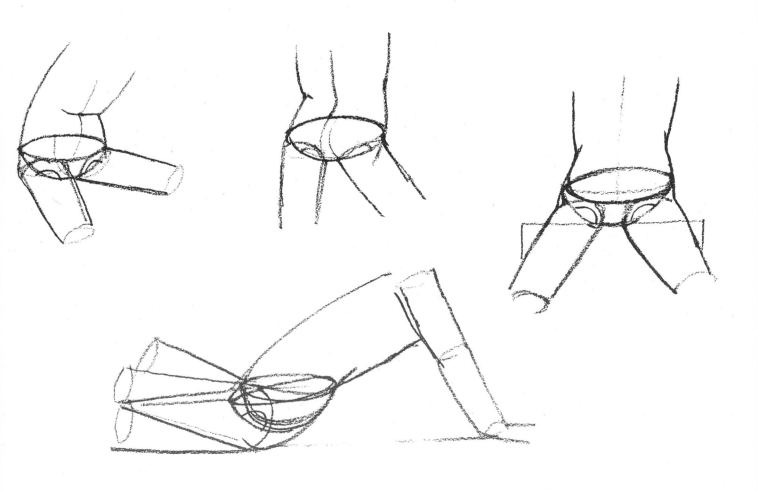

Positions of pelvic basin into
which the base of the trunk
is 'inserted'.

Left. Comparison of similar
movements by robot and
human figure.

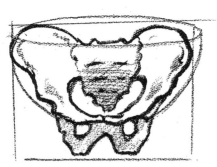

MALE PELVIS.

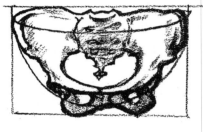

FEMALE PELVIS

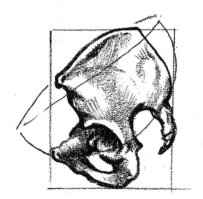

MALE PELVIS. SIDE VIEW

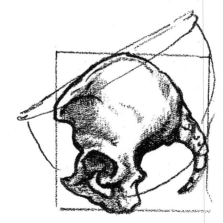

FEMALE PELVIS. SIDE VIEW

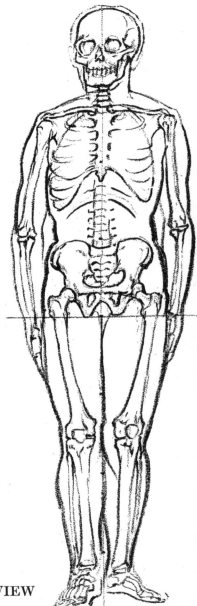

MALE. FRONT VIEW

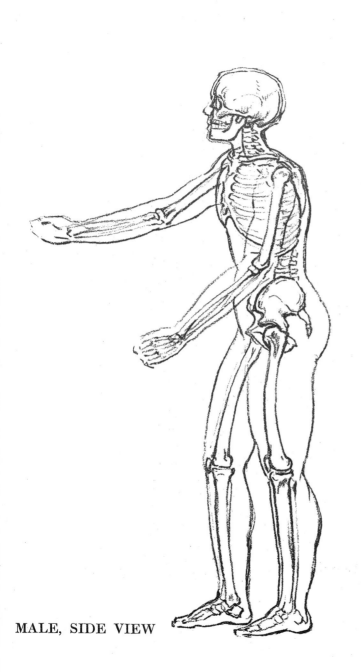

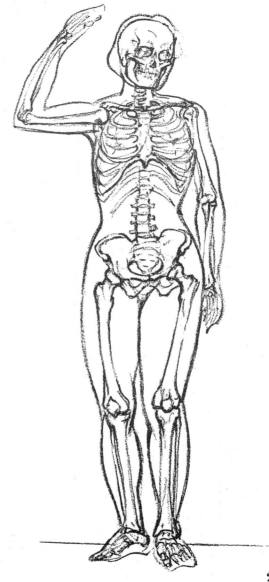

MALE, SIDE VIEW

FEMALE. FRONT VIEW

21

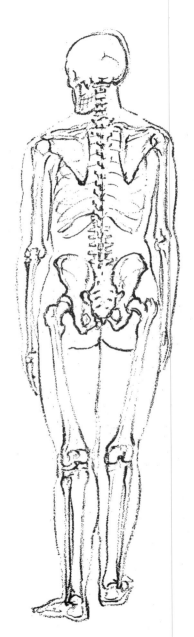

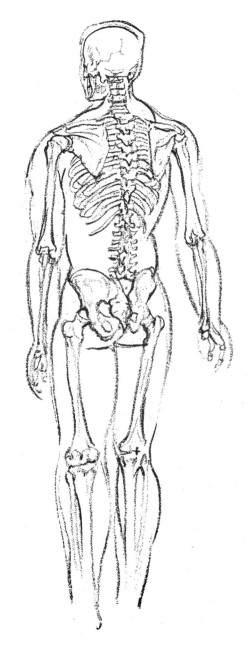

MALE. BACK VIEWS

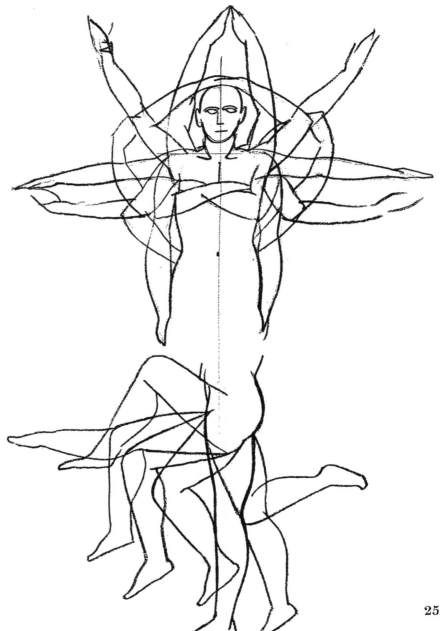

Two diagrams showing the freedom and diversity of the arm movements against those of the legs.

25

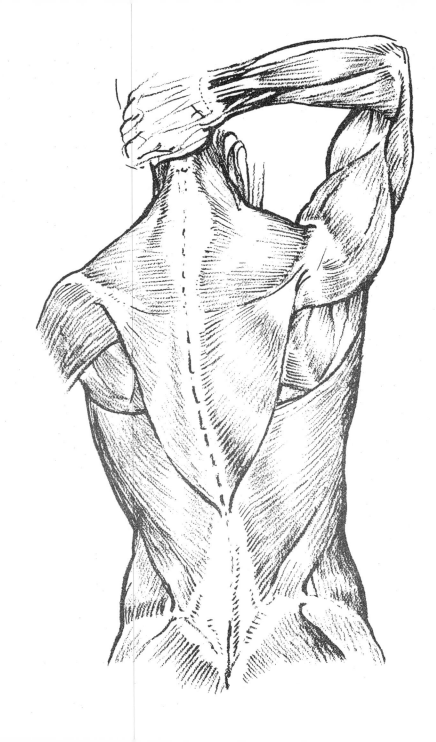

The Muscular System

It may be surprising as well as interesting to learn that there are about 480 individual muscles in the body. The majority of these, however, are of no concern to us as artists, and those that are can be placed in three categories. Naturally they vary exceedingly in size, length and thickness, and are arranged in two or more layers : (1) deep seated ; (2) superficial ; and (3) subcutaneous (just under the skin). It is the latter groups which concern the artist. Nearly all these muscles are attached at both ends to the framework of the bones. On the trunk the superficial muscles are *broad, flat* and sometimes *thin*. On the limbs, the muscles are *long* and *rounded* while their tendons are *flat, tapering* and *divided* to reach many bones.

The actions are numerous. Some *flex*, some *abduct*, some *adduct*, others *rotate*, and when they all co-operate together they are said to *circumduct*. Moreover, in addition to these important and varied movements, the muscles acting together keep the figure erect and also enable the body to sustain weights.

The manifest influence they can have on the surface modelling is obvious. They give *breadth* and *smoothness* to the trunk, *roundness* and *richness* to the limbs, especially round the thighs, and present graceful contours and modelled surfaces of great variety and character to all parts of the body. Indeed (and this is important) they make sense of the bulges, hollows, projections, ridges and curves with which the body can be said to be decorated or embellished. If, as has been quoted, the skeleton furnishes examples of still life, then the muscles illustrate life in motion and quicken the inanimate into action. We have only to go through the motions of heaving, hitting, reaching, clutching, swinging, catching, lifting, squeezing—twisting and stroking, if that is not enough—to be made aware what the muscles are responsible for in these varied uses of our arms and hands.

To go through the various motions of

walking, running, jumping, kicking, kneeling, crouching, stretching, is sufficient in itself to realise the similiar diversity of the leg muscles, which, if they cannot compare in variety with those of the arms and hands, have an additional duty to perform, for while they can fold up (like a ruler) when we sit on the ground (with our knees drawn up to our chin), when braced in the erect position they can easily support the weight of the body, however many movements are made by the trunk and arms, and if need be this support can be equally well taken on one leg, and in dancing (for brief moments) can even be balanced on the toes of one foot!

Before describing these muscles in detail we must return to our tubular figure and introduce some modifications in the cylindrical shapes. To take the trunk first, which has been so far represented by a thick column, the rigid outlines of this will now be influenced not only by the bony structure which has been introduced but by the muscular coverings.

The back of the trunk can now be divided by a vertical line, on each side of which are placed two rounded forms. When we stand upright with our shoulders back, these forms press against the backbone causing a *furrow* which will disappear and be replaced by a bony ridge when we bend over forwards (see illustration on page 32).

On the front of the trunk the breast bone forms a short *vertical* line between two *horizontal* swellings of the chest. From the base of this breast bone line the cylinder is divided into *three vertical* forms which extend down to the *base* of the column (see illus. on page 40). On either side of the trunk, arrow shaped swellings wrapping *round* the ribs are only visible on the male body (illustration on page 42).

The thighs are more subtly modified and can still be portrayed as cylinders slightly flattened at the sides.

In the lower legs the cylinders will show a swelling at the back and a tapering towards the ankle.

The upper arm swells where it joins the shoulders, and the lower arm tapers gradually as it joins the wrist and hand.

This simple remodelling of the nine cylinders has now achieved a far closer resemblance to the human standing form

and indeed we might well stop there but for the desire to draw the body in action and in different positions, and to do this with any degree of success we must pursue our investigations of the parts which are affected by movement, whether it be normal and slight or vigorous and strenuously purposeful.

If you look at page 26 you will see two further additions to the relief map of the back of the trunk. Now we come to a slight complication : it is when one muscle overlays another, such as happens when the hodlike shape of the trapezium is not only attached to the base of the skull but wraps over the shoulders to be attached to the collar bones and is in turn stretched over the top of the back of the ribs to be tied at the base of the backbone and along the top ridge of the shoulder blades. A similar covering is seen in the broad sweeping muscular shape which is tied at the base to the top of the pelvic basin and halfway up the backbone and stretched out by a tendon so that it can be inserted into the bone of the *upper arm*. Both these shapes on the surface of the back of the trunk can be seen clearly when we lunge out with our arm.

The triangular intervals left between the interlacing of these covering muscles are filled in by other smaller contours over the shoulder blades which, in backward movements of our arms, proclaim the existence of other smaller muscles and afford minor configurations on the surface which should not be overlooked.

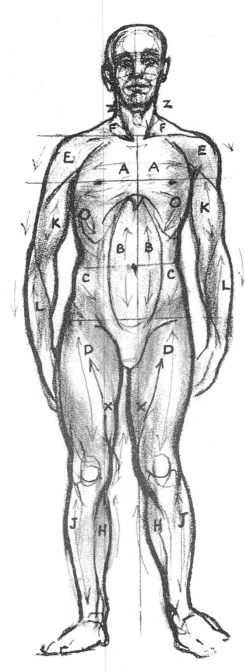

STERNOMASTOID. (Z)

DELTOID. (E)

PECTORAL. (A)

TRAPEZIUS. (F)

SERRATUS. (O)

RECTUS ABDOMINIS. (B)

EXTERNAL OBLIQUE. (C)

BICEPS. (K)

SUPINATOR. (L)

RECTUS FEMORIS (D)

SARTORIUS. (X)

EXTENSOR. (J)

FLEXOR. (H)

Each muscle has its own directions, vertical, horizontal and oblique, and each blends with its neighbour.

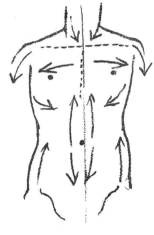
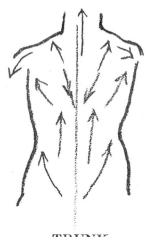
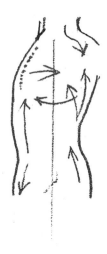

FRONT

TRUNK
BACK

SIDE

Main directional lines
of the muscular sys-
tem.

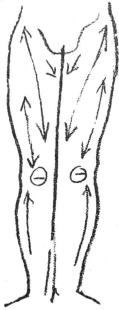
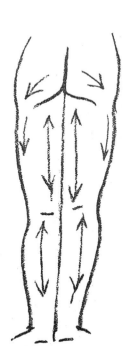
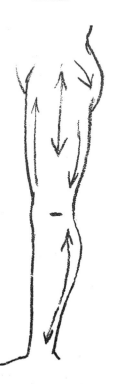

FRONT

LEGS
BACK

SIDE

31

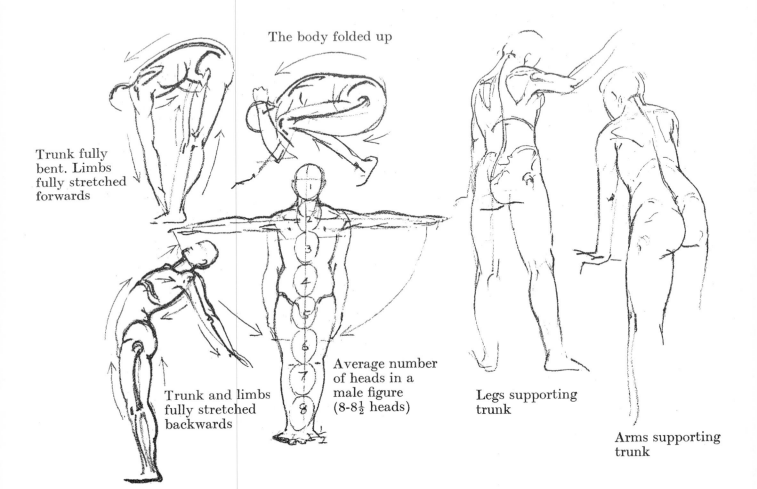

The body folded up

Trunk fully
bent. Limbs
fully stretched
forwards

Trunk and limbs
fully stretched
backwards

Average number
of heads in a
male figure
(8-8½ heads)

Legs supporting
trunk

Arms supporting
trunk

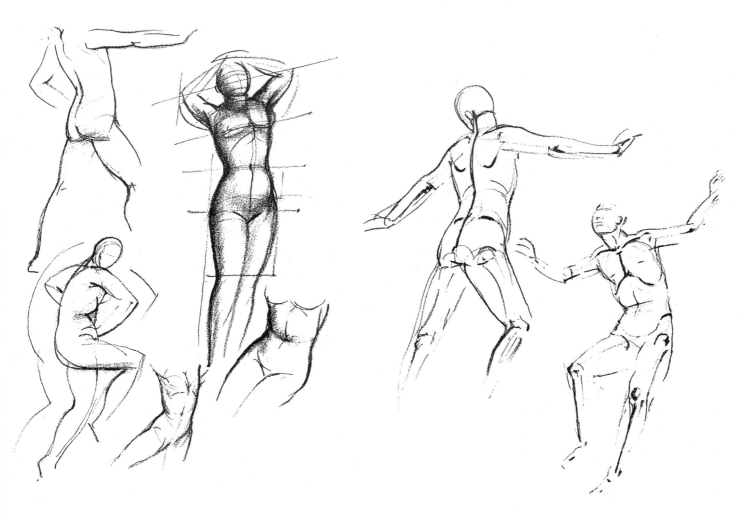

Studies of the torso, where line or tone can each emphasise the degree of movement employed.

Superficial bone markings of the figure in action.

33

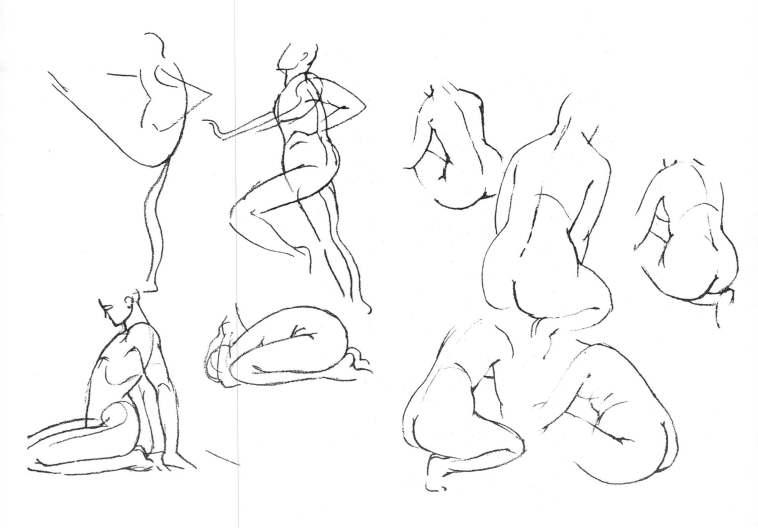

Studies in line which can depict both physical and mental strain.

Five line drawings showing the subtle difference of the genteous muscles of the female form when sitting, kneeling or crouching.

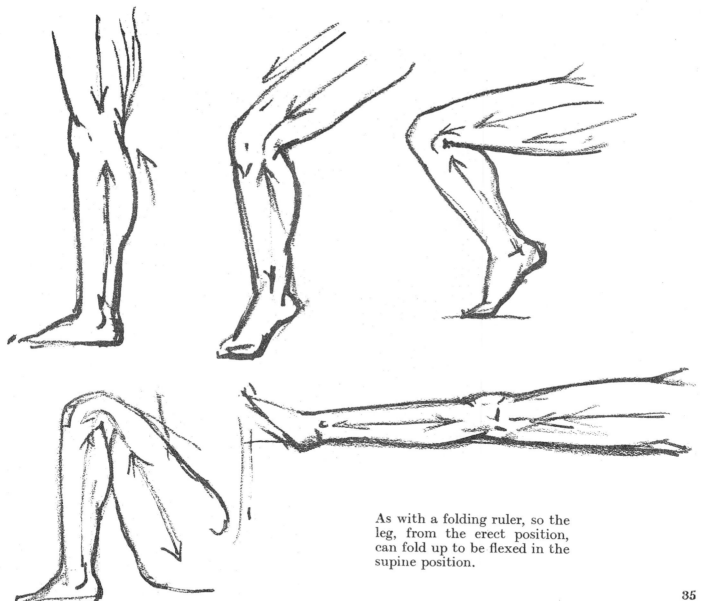

As with a folding ruler, so the leg, from the erect position, can fold up to be flexed in the supine position.

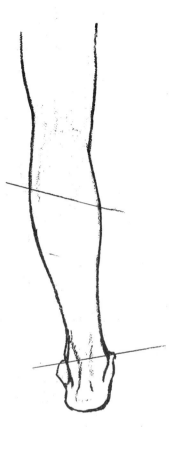

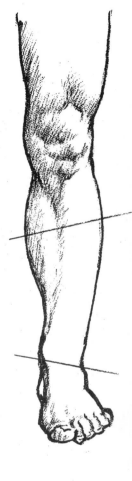

Outline shape of
calf. Left leg. Male

Muscles of calf.
Right leg. Male

Outline shape of calf.
Left leg. Female

Front view of
left leg. Male

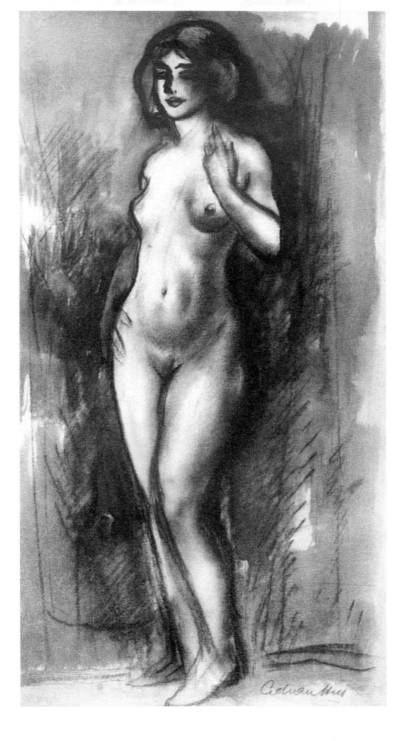

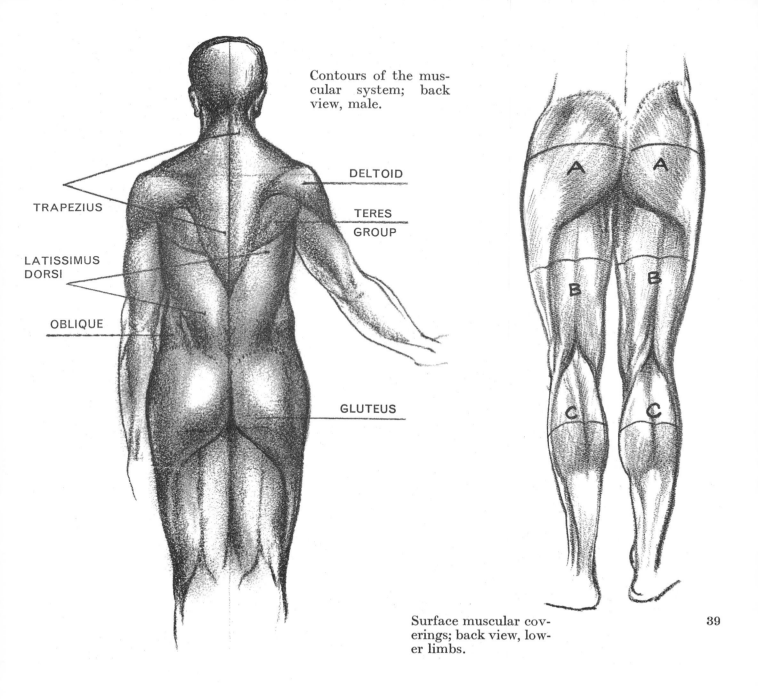

Contours of the muscular system; back view, male.

DELTOID

TRAPEZIUS

TERES GROUP

LATISSIMUS DORSI

OBLIQUE

GLUTEUS

A

A

B

B

C

C

Surface muscular coverings; back view, lower limbs.

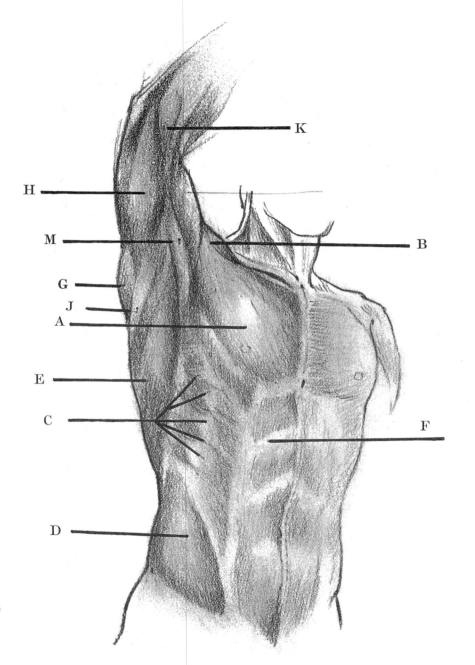

The surface muscles of the trunk and upper arm

A	Pectoralis major
B	Deltoid
C	Digits of the serratus major
D	Obliquus externus
E	Latissmus dorsi
F	Rectus abdominis
G	Infraspinatus
H	Triceps
J	Teres minor
K	Brachialis anticus
M	Coraco-brachialis

Right. Suggested method of foreshortening trunk, shoulders and head. The tubular man comes to our aid.

Far Right. Note very carefully the shapes which occur between the right arm and the body and between the two legs (A, B). Notice how the tendon (C) runs into the upper arm on the left; contrast between the gluteus muscles, that on the right being contracted (D), that on the left relaxed (E).

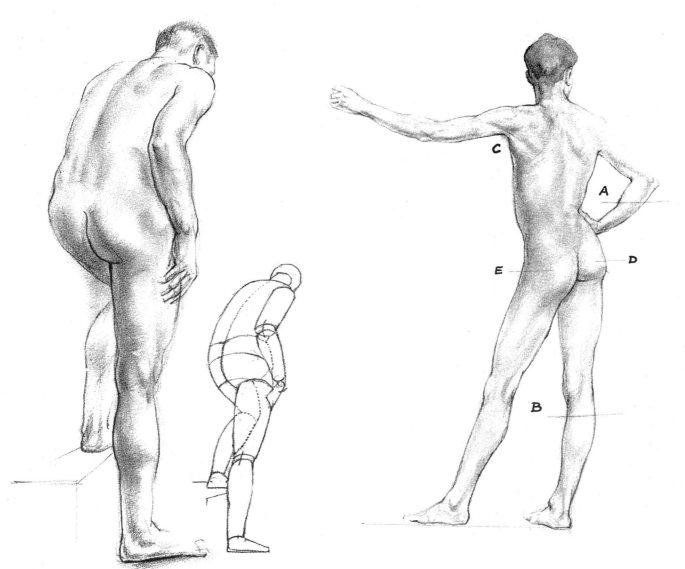

41

Plan of the areas occupied by the chief surface muscles on the shoulder, arm and trunk of the sitting figure.

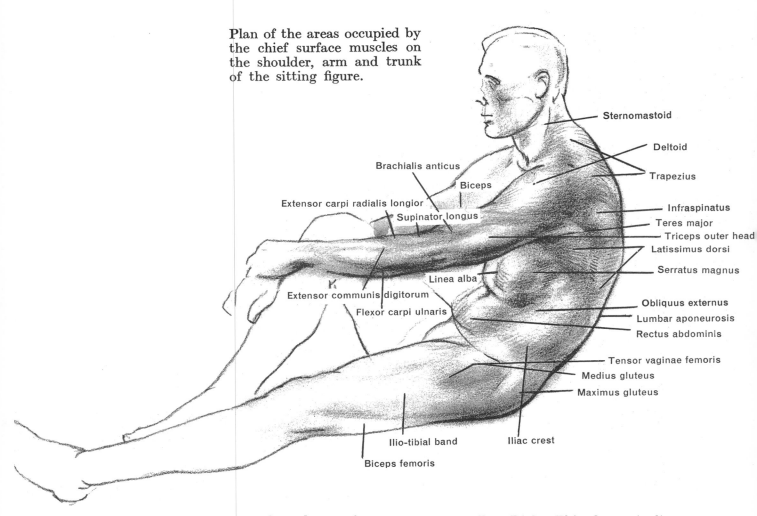

Sternomastoid

Deltoid

Trapezius

Brachialis anticus

Biceps

Extensor carpi radialis longior

Supinator longus

Infraspinatus

Teres major

Triceps outer head

Latissimus dorsi

Serratus magnus

Linea alba

Extensor communis digitorum

Flexor carpi ulnaris

Obliquus externus

Lumbar aponeurosis

Rectus abdominis

Tensor vaginae femoris

Medius gluteus

Maximus gluteus

Ilio-tibial band

Iliac crest

Biceps femoris

Right. Note the slant of shoulders, hips and knees (A); the influence of the femur when hip is thrust outwards (B) and the freedom of the thigh and leg (D). Muscles of the flexed right arm (E, F, G) are emphasised. Also note the shapes at X.

Far Right. This figure is lit from the right, thus bringing into full relief the muscular action of the left-hand side of the torso.

42

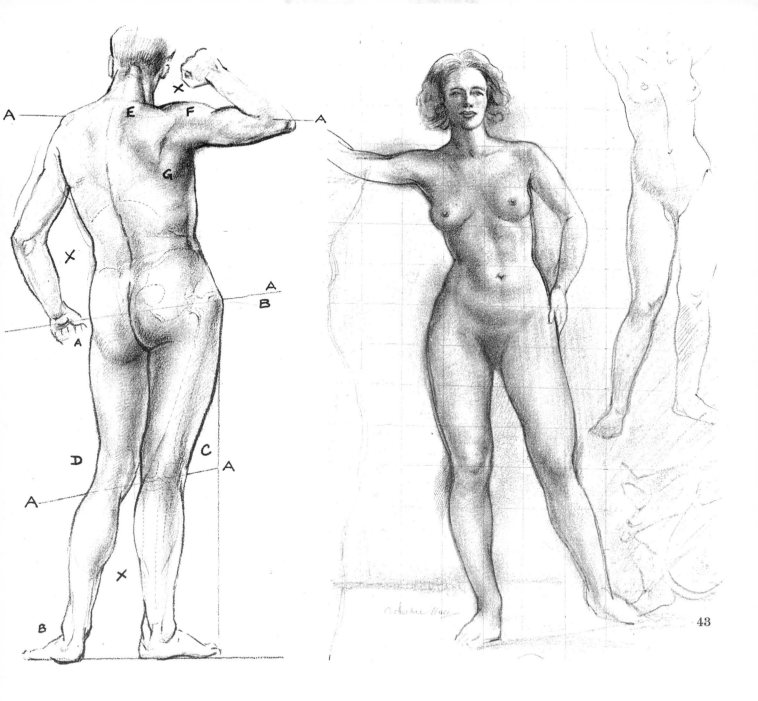

43

1

2

3

4

Whether it be tight trousers and coat as in Fig. 1, or the thick, loose pullover in Fig. 2, or the raincoat in Fig. 3, or the casual drape of the sporting jacket in Fig. 4, the solid structural body underneath must never be lost sight of.

Essential folds which suggest
the form beneath.

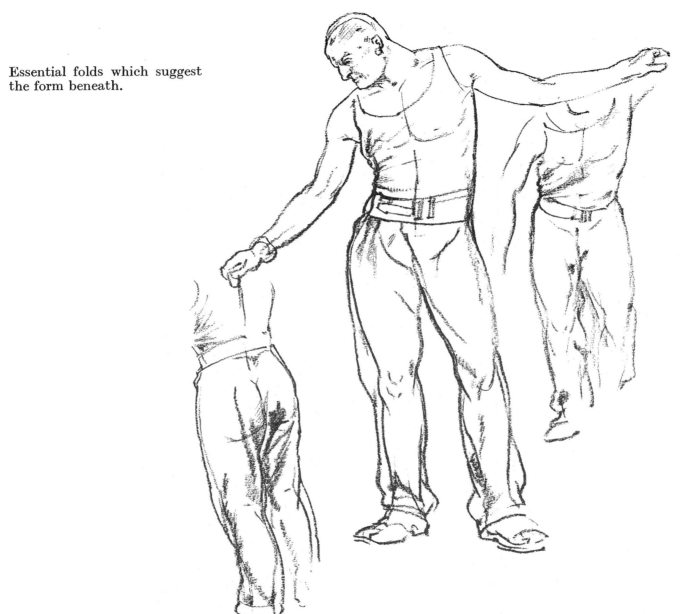

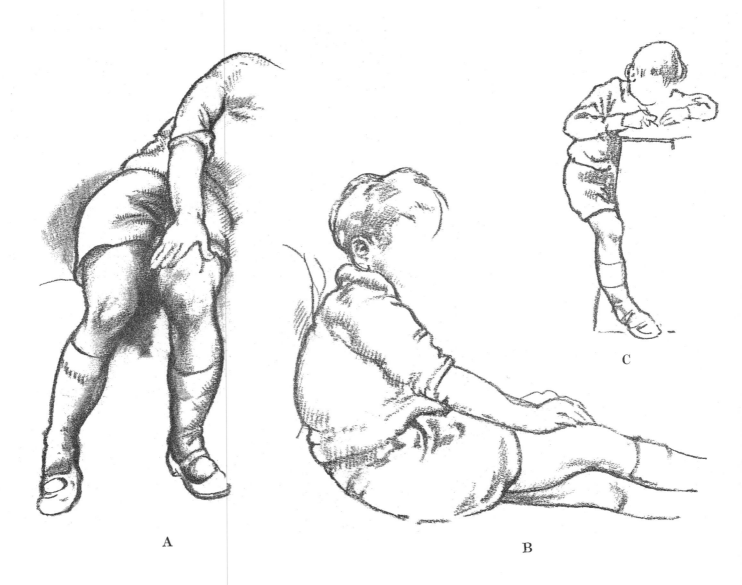

A

B

C

Left. Child Studies

A Note the positive action of the hand on the knee in contrast with the wayward disposition of the legs. Only in the very young do the legs appear to wander.
B The woolly jersey and thick shorts disguise the child's body.
C Note the proportion of head to body, and hands to feet.

In these studies (right), the child's legs are most important.

A A position is struck. The left leg is advanced, the right pressed back; the body supported by the arm.
B The legs having nothing to do but dangle.
C The legs, though bent, are at rest.

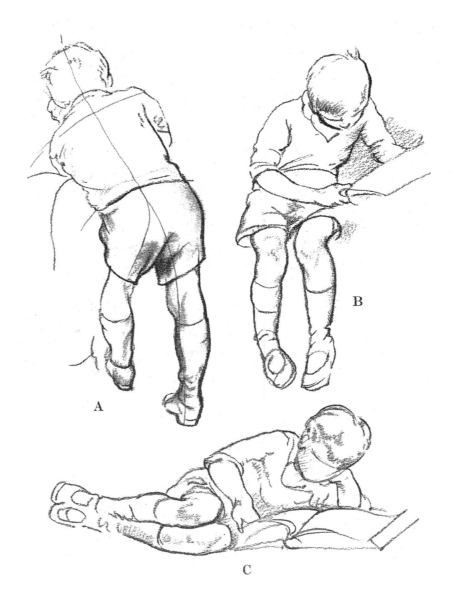

A

B

C

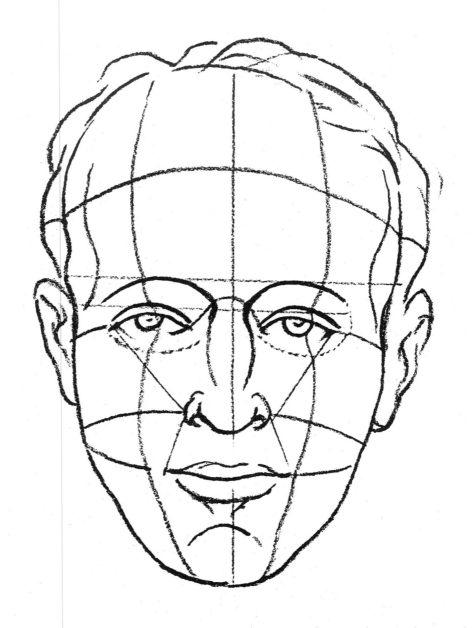

The Head

The bony structure of the skull, apart from the fleshy portion of the cheeks, influences the other surface forms in a very marked degree. The skull is composed of two parts : the upper or cranium, and the lower or *movable jaw* (illustration on page 5ε).

In drawing and painting portraits only a thorough working knowledge of these bones can assist in the depiction of the individual features and thus lend personality to the sitter, in short in achieving what we call a ' striking ' likeness, without which the portrait must be doomed to failure, however well it is painted. And as no two faces are similar, the often subtle discrepancy in width and length of one feature or another, if not observed and rectified in the preparatory drawing, will only result in what can be described as a ' near miss.'

But before we particularise in these assessments, let us return for a moment to the egg shape which sufficed for the head of our tubular man. Let us carefully notice that the eyes are set in *sockets*, that it is between the lips that we open our mouths, and that this line, whether open or shut, must *follow* the *contour* of the head, that the nose is a wedge-shaped *projection growing out* of the contour of the face and must be represented thus, not only in profile when it is easy to see but full face when it is far less so ! That the forehead can advance over the eyes (or slowly retreat !) and that the chin has strength or weakness (see illus. on page 48). And finally, that the ears are placed at, or, better still, can be said to be *attached to* the side of the head, and move up or down as the head moves ! (Illustration on page 50).

For the next course of study I recommend drawing your own face in a mirror, staring yourself out of countenance, if need be, so that you become properly acquainted with all those subtleties of feature and form which makes you, you !

When you have mastered your own features you can turn with more confidence to record accurately those of your friends,

for it is only through the experience gained by drawing all sorts and conditions of face (if I may put it that way) that you note instinctively the subtle little differences in the length, width and *slant* of features which distinguish one head from another, stamping each as an individual, and believe me, basic anatomy, a knowledge of the skull in this case, will prove the right answer to all your problems in this respect.

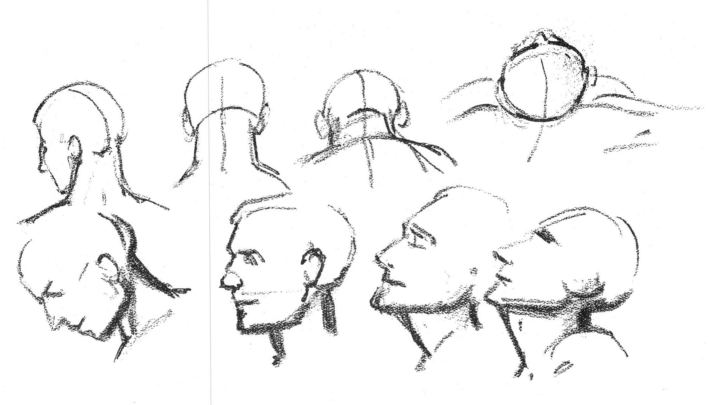

Various movements of the neck and head in which pictorial emphasis can denote flexion or extension.

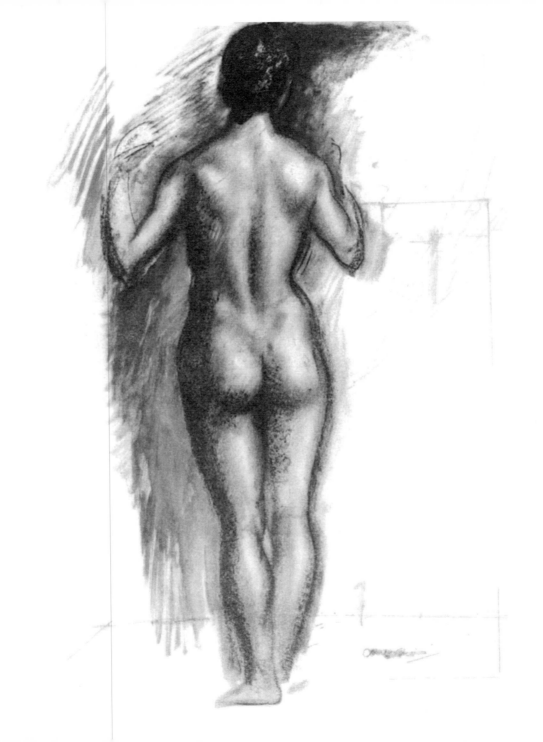

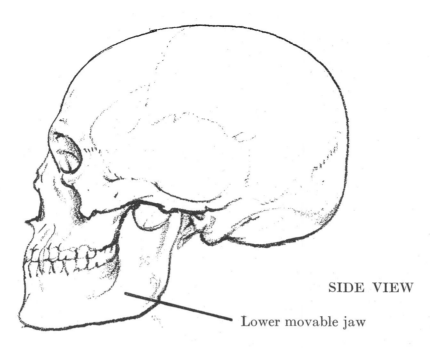

SKULL

SIDE VIEW

Lower movable jaw

FRONT VIEW

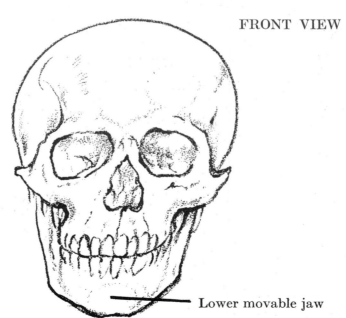

Lower movable jaw

53

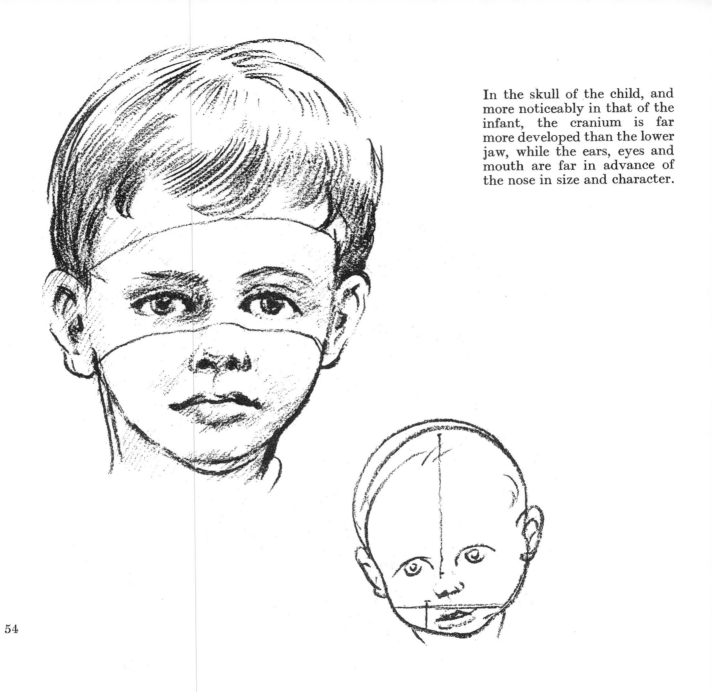

In the skull of the child, and more noticeably in that of the infant, the cranium is far more developed than the lower jaw, while the ears, eyes and mouth are far in advance of the nose in size and character.

54

In old age, the simple facial contours of youth become strongly modelled and deeply furrowed. The eyes, retreating into their bone sockets, cause the nasal bone to become, by contrast, more pronounced.

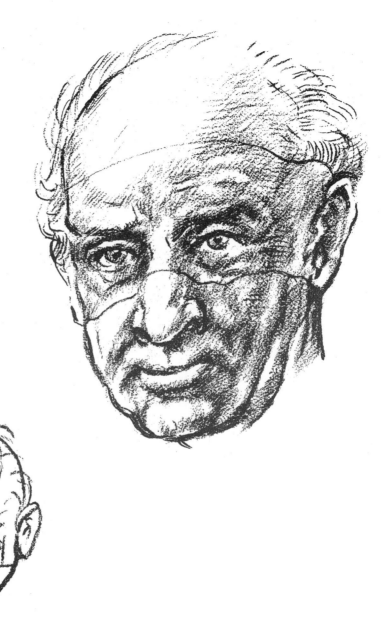

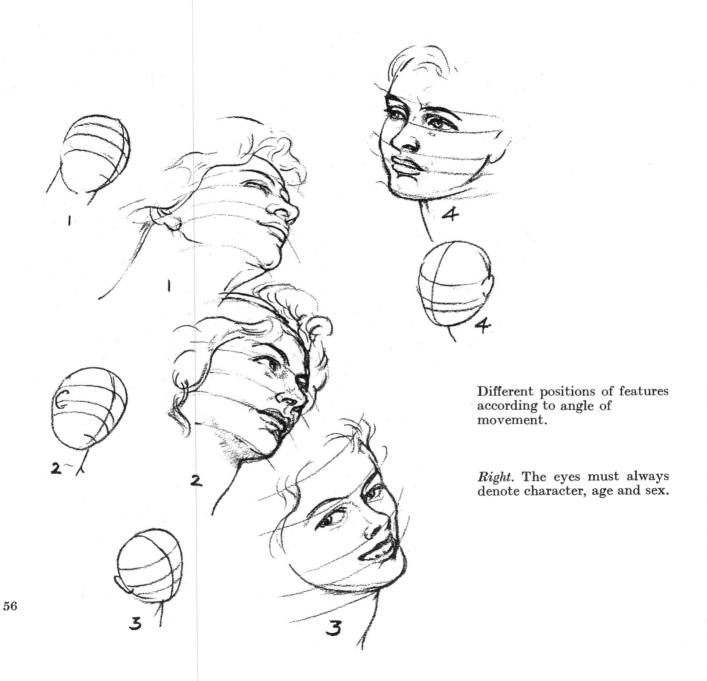

Different positions of features according to angle of movement.

Right. The eyes must always denote character, age and sex.

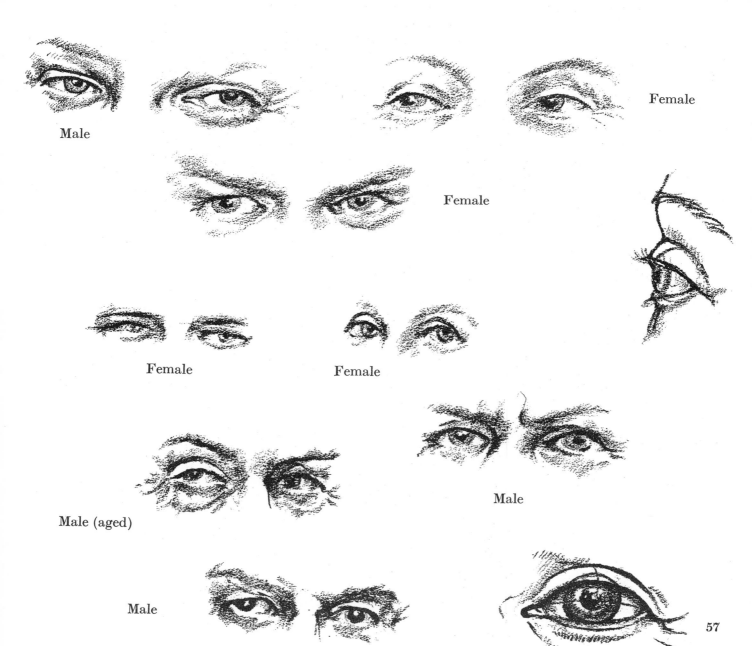

Male

Female

Female

Female

Female

Male (aged)

Male

Male

57

Male ear, left side
1 Helix
2 Anti helix
3 Concha
4 Meatus
5 Tragus
6 Lobule

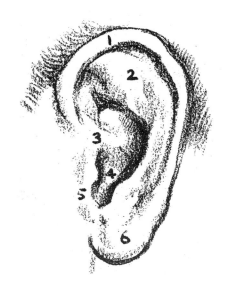

There is a great diversity of configuration in the construction of the ears of children and adults of both sexes, as will be seen in the accompanying illustrations.

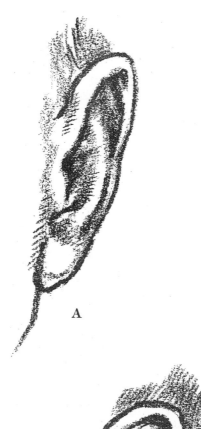

A

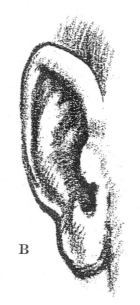

B

A Male ear (old) as seen in
 full face; left.
B Male ear (young); right.
C Male ear (adult) as seen in
 profile.
D Young boy's ear as seen in
 profile.

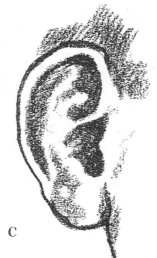

C

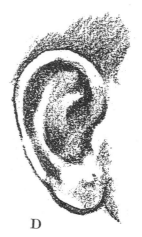

D

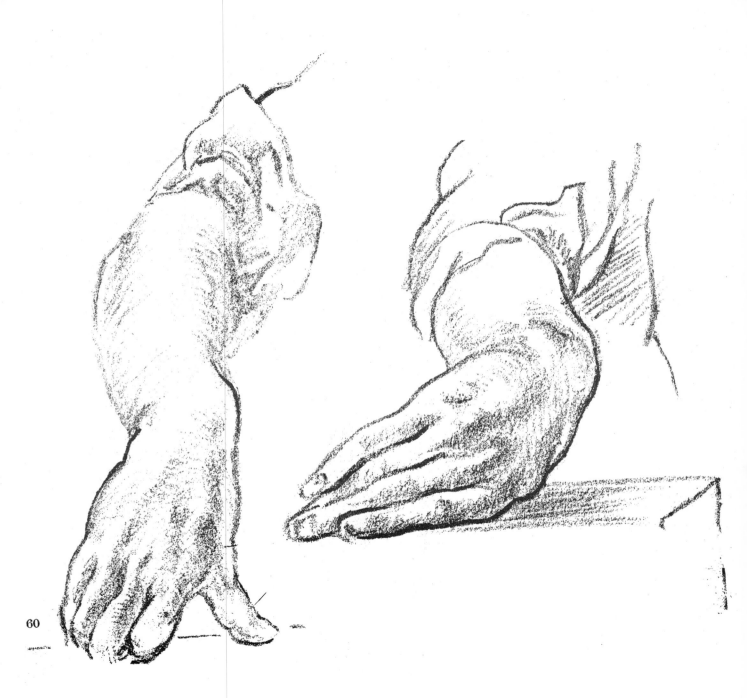

Hands and Feet

The correct anatomical construction of the hands and feet is often neglected in the study of the human body. This is to be deplored, as both features are of major importance if the working of the overall framework is to be properly understood. In the hands, especially, great diversity of character is displayed. Quite apart from the fascinating multiple movements of the fingers, it is in the proper regard for character that close attention is required in the size, shape and length of fingers in relation to the width and contours of the hand proper. Old hands differ greatly from young hands.

When the fingers and thumb are drawn together, their various lengths are established, and it will be seen that the second finger is the longest, the index and third digit are equal, while by the set of the bones in the wrist, the top of the thumb barely reaches to the first joint of the index finger. When spread out fanwise, the span of the thumb is far wider than the interval between the four fingers. The arrangement of the extensor tendons determines to a great degree the natural grouping of the fingers, especially in the various movements of extension, assumed in all free movements of the hand. As an example, when pointing, the index finger is extended and slightly adducted, while the three associated fingers are naturally flexed with or without the thumb. The three inner fingers are usually associated in other movements of extension while the little finger remains independent owing to its possessing a special extensor. When the hand is clenched in a fist, the flexed thumb wraps over to cover the first joints of the index and second finger.

In contrast with the hand, the most important feature of the foot is the great toe, well named as it far exceeds the size and breadth of the remaining toes which are seen to be bunched together and normally move in unison and should be portrayed as working together. It should be remembered that the foot, for a great part of each day, is responsible for *supporting* the *weight* of the entire body, and the extent or relative freedom of movement when not engaged in the standing position places it in *flexion* rather than *extension*. As in the fingers it is very free in the first joints, so that the toes are brought together firmly on the ground.

Hands and feet are often drawn too small, and such a fault weakens the whole structure.

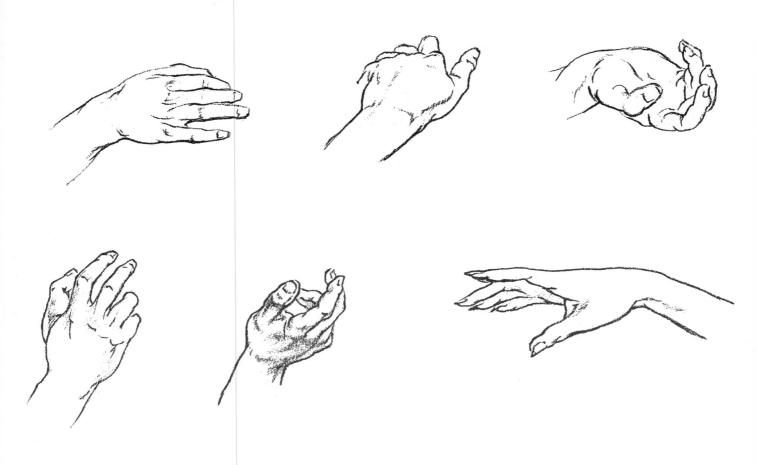

Some of the multiple movements of the hand made possible by the rotary action of the radius over the alna bone in the lower arm.

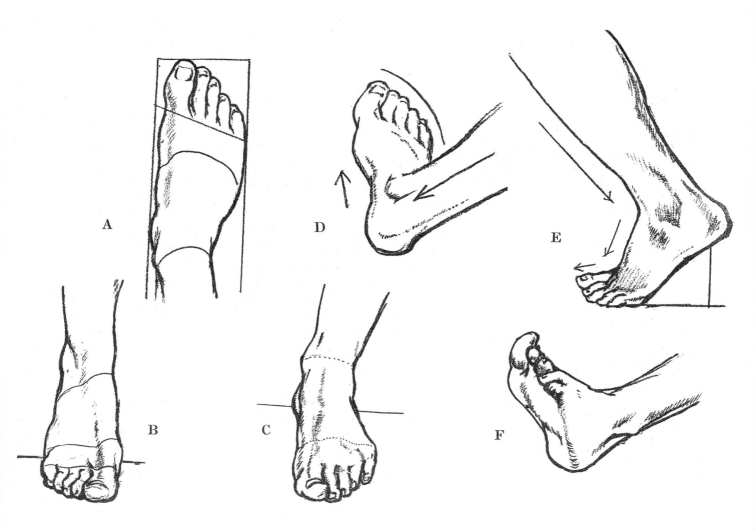

A Shape of foot
B Standing foot, on the toes
C Standing foot, flat heel
D Raised heel, looking down

E Raised heel, side view
F Kicking foot, three-
 quarter view.

Conclusion

The sole aim of this little book has been to vitalise as well as reconcile the importance of basic anatomy with its logical application to the contemporary portrayal of the human figure, to prove by means of simple demonstrations that the more knowledge we possess of the human structure, the *greater freedom* we shall achieve in pursuing *our own aims* in the proper and *personal* expression of them.

Names of bones and muscles are of little practical use and of no artistic significance whatever without a clear understanding of how and why these names work. In short, what the surface modelling in the *living* figure means to us in terms of drawing and painting.

Copying superficial markings as if one were filling in a map, without knowing why they influence the surface as they do, can only produce stereotyped ' tailor's dummies', lacking that essential sensitive touch governed by the knowing eye, without which any drawing must remain ' still born'.

And finally, here is a warning by Ian McNab in his book *Figure Drawing* (Studio Books): 'Once a knowledge of structure and surface anatomy has become *instinctive* it will help the student to produce drawings which have *aesthetic* merit, but while it is still too consciously in his own mind his anatomical knowledge may prove more of a hindrance than a help.'

The truth of this I hope I have foreshadowed in the body of this work.